Wishes in Black & White

by

Eileen Williams Sabry

Robert D. Reed Publishers
San Francisco, California

This book is sold with the understanding that the subject matter covered herein is of a general nature and does not constitute professional advice for any specific individual or situation. Readers planning to take action in any of the areas that this book describes should seek professional advice from their own advisers—as would be prudent and advisable under their given circumstances.

Robert D. Reed Publishers
750 La Playa Street, Suite 647
San Francisco, CA 94121
Phone: (650) 994-6570 • Fax: -6579
Email: 4bobreed@msn.com
Website: www.rdrpublishers.com

ISBN 1-885003-55-2

Library of Congress Catalogue Number: 00-190619

Printed in Canada

Dedication

Edward Dugger

Ridvan Foxhall

Saba Golestaneh

Gallery Group

Reza Namazi

Ashraf Sabry

Hooshmand Sheshberadaran

Paul Shio

To friends and family who believed in this project.
Special thanks and much gratitude to the people
who had the courage to share their wishes.
Ultimate thanks to our parents, our first teachers.

And to Bob Reed and Pam Jacobs, at Robert D. Reed Publishers,
who were willing to take a chance on this sensitive subject.

Introduction

It has always been difficult for me to understand why people have separated humanity along ethnic lines. This issue inspired me to write this book about communicating the needs of Americans. I interviewed forty Black and White Americans in various professions and asked each person the same question: "Regarding race relations in America, if you had one wish to share with the other group, what would that be?" This book includes some of their wishes.

While people may appear different, in essence, we are all human beings no matter what our skin color or background. Still, racial issues have had a powerful impact throughout our history and have jeopardized human harmony in America. My wish for this book is to contribute in any way possible to harmony in our country. Clearly, a lack of understanding and respect for one another is not healthy for anyone and not productive for our future.

The United States has a history of being torn apart by misconceptions – unproductive views of one group of Americans about another group. Misunderstandings have resulted in a divide along racial lines. This divide is at the root of many other challenges facing all of us today – such as increasing violence, social unrest, and a sense of helplessness. I believe that open and honest communication is an important first step in uniting Blacks and Whites.

Several books that I have read clearly dispel the myth that one group of humans may be superior to another group based on ethnic makeup. Yet some people are still trying to prove that which is not provable: that one portion of the world's people is genetically superior to another. Anyone can find arguments to substantiate whatever point of view he or she may have. But these arguments are merely aimed for or against a particular view; they do not necessarily represent the "truth."

Skewed perceptions and fixed perspectives create disharmony and separation. They imply judgment or conclusions open for dispute. A belief, however, is a state of mind or habit in which trust and confidence are placed. Unfounded, negative, and limited perspectives are damaging. They create misunderstandings and lost opportunities for communication, cooperation, and growth. By placing too much emphasis on fixed perspectives, we give them too much energy, weight, and meaning. And by wasting our precious time trying to prove them wrong, we get distracted and lose focus on our beliefs and goals.

I believe in the oneness of humanity and its positive impact on America's future. I am confident that a united America will prevail. Therefore, I do not feel the need to dispute any particular perspective – such as the superiority of one group over another.

For too long, it seems that we have been more preoccupied with mounting judgments and evaluations of one another, rather than communicating our needs. But we can listen to one another, express ourselves more effectively, respect each other, and work toward common goals. Imagine what our lives could be like by working together and creating a more unified country?

This book suggests one way to begin improving race relations. Hopefully it can serve as a catalyst for opening communication between Blacks and Whites, the two groups that have been the most polarized in America.

Most Americans, Black or White, will remain in the United States and call this "home." While some people may try to live as far away from the other group as possible, most of us hold jobs and run businesses that require close interaction with each other. A truly persistent separatist will even try to work and live where there is minimal to no contact with the other group. This book is not intended for them. It is intended for Americans who have to and want to live and work together peacefully and productively.

For years I searched for books that might offer solutions to the racial divide in America. I was most perplexed by those authors who claimed that the United States did not have a racial problem. Some people insist there is no divide, but clearly there is not much understanding, acceptance, or cooperation. I have seen documentaries that provided various perspectives on racial harmony. However, no one clearly stated what he or she wished from others.

Today, despite the startling statistics about the disparity in economics of Blacks to that of other groups in America, there is a viable Black middle class. Yet there is still a divide between Blacks and Whites of the middle class. Blacks are fully valued in many fields of human endeavors. They have moved up in the highest ranks in the U.S. Military and Fortune 500 companies, and they have continued to build successful businesses.

I have looked at what has not been communicated between Blacks and Whites in America. Both have a relationship by virtue of living and working in the same country. Perhaps their perceptions and fixed perspectives have overshadowed what they *really* want to say to each other.

Asking for what we want from others does not guarantee that we will get it. However, by communicating our wishes we give others the opportunity to consider fulfilling them. Having our wishes acknowledged is satisfying; having them fulfilled is empowering. Wishes can become a reality when we believe in them and take action. Asking for what we want is one way to begin to take action. For example, some people say that, "Racial harmony will never happen in our lifetime." Instead, why not wish for that and help to make it a reality?

Leaders who have taken on the tremendous responsibility of representing Blacks and Whites in the United States have the difficult task of finding common threads of interest. Common threads include: our interest in fairness, our desire to live the "American Dream," safety and security for our families, access to high quality health care and education, freedom, spirituality, and more. Threads begin to unravel, though, when we try to resolve our differences.

America's population is rich in diversity and so are the views of its people. Forty people interviewed for this book were willing to share their views on racial issues, a highly sensitive subject. By being willing to communicate honestly, as they did, we can all begin to understand each other and find common ground.

By writing this book, I do not attest to being an expert on this subject. I only wish to participate in whatever ways I can to resolve the insidious racial conflicts that are eating away at the very fabric of this great country. As an American citizen, I feel it is my responsibility to use whatever skills I possess for the betterment of society. My heartfelt wish is for the well-being of all Americans and our country as a whole. In working toward this important goal, I envision a future where people of all backgrounds love and respect one another.

– Eileen Williams Sabry

Photographer's Comment

Many have asked me why I became involved in the completion of this book since my background is Iranian-Canadian. Although I represent neither Black nor White Americans, I do not feel removed from the fundamental issue of race relations in America. I believe that when a race, nation, or any group of people is suffering, humanity as a whole suffers collectively. Much like when a single part of the anatomy of one's body is in pain, that entire being becomes afflicted. Until we own the pain and effects of racism, prejudice, and any form of oppression, we will continue to stunt the growth of humanity. Thus, my answer is that I am already involved!

– Roya Movafegh

Regarding Race Relations,

What Do You Wish

Of Blacks Or Whites?

Your way is one way, not the only way. Your culture is one culture, not the only culture. Your perspective is one perspective, not the only perspective. Can't you see me? I'm right here in front of you. Looking into your eyes for recognition of me.

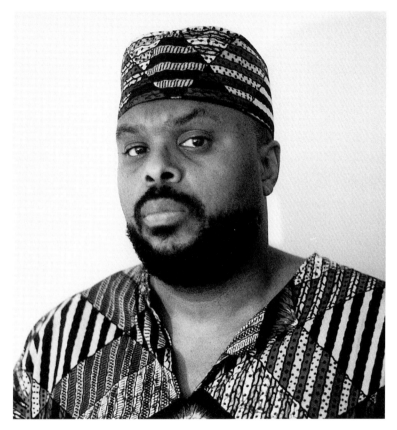

Carl Murrell, Aide for an NGO of the UN

My feeling is that Black Americans tend to isolate themselves from White Americans. White Americans wanting to be part of the black community have difficulty finding acceptance.

I believe that Black Americans, based on their history, are more tapped into humanity. Personally, my sense of humanity has been enriched from exposure to black culture. White Americans can learn from the wisdom of Black Americans. They have a lot to share.

My hope for Black Americans is that they find peace within themselves and rise up to take leadership positions in this Country. If they do this, they could lead the world toward a better future. Without them, it will be much more difficult to achieve peace. They should not be afraid to stand up because what they have to say hits a deeper cord for me than what I hear from White Americans. It lights me up to hear a Black American speak. They often speak from their heart.

Nancy Yates, Auction Specialist/Curator

Respect

Viola Wood, Retired Micro Biologist

If I could ask anything of Black people, I would beg them to recount their tale over and over again a thousand times, loud enough and long enough, so that every one would know what they've seen and get just a glimpse of their collective pain and have some clue of what it is like and what it was like to survive the extremities they have experienced on this planet.

Ruhi Reimer, Banker

Stop & Consider

Michele Henry, Activist

The problem of racism arises, like many other problems in the world, because people have lost a sense of focus; determining what is really important in life. Slavery, the true beginning of the racism problem in the Americas, arose out of capitalist greed. Before that period you can find African's taking prominent roles in cultures all over the world; St. Augustine for example. Capitalism forced people to honor money and power and at the same time demonize the black race, something which they had to do in order to allow their inhuman behavior. This scenario has changed over time, but negative stereotypes still persist. They serve to "empower" the people who believe in them by making them feel superior. Power, money, whatever, it doesn't matter. We are all relegated to die one day, so what really matters? Survival and personal evolution in this life time to make your life more productive and the life of your children better. What good is racism if these are the values you hold dear and not power and money? I just wish everyone could see THIS.

Tony Gumbs, Entrepreneur

My wish is for people to judge others by who they are, by their deeds and their actions as a whole, not by their race or ethnicity. When a negative statement is credited to someone, we should not quickly jump to judge and condemn, but need to stop and ask, "Is that a statement or action that that person would say or do?" We cannot afford as a world, to stand ready to fight and hate. When allowing ourselves to know people one on one, we can break these barriers and foster friendship and understanding.

Jane Hamilton, Special Education Teacher

I wish the African American Community would try to get to know me better. I have African American friends and friends of many other cultures, who take the time to get to know me. I wish that everyone would extend themselves and do a little work to get to know each other better. When my friends and I get together, we are aware and appreciate our differences, but we find out that there are a lot of things we have in common as well.

Chris Cesare, Fitness Center Manager

I wish White people would acknowledge the wrongs they have committed and continue to commit against people of color, specifically African Americans. With that acknowledgment, I would like to see 'justice' prevail through an evolutionary change in the attitudes of Whites towards African Americans. This change would be inclusive of reparations reflected in social and economic parity and equitable treatment in all areas of life. Until such a change occurs, there will be no unity between African Americans and European Americans and thus, no peace for America.

Joy De-Gruy Leary, Psychologist

I would like both Blacks and Whites to work together on fairness and justice and for them to work together on combating the discriminatory practices that currently take place in this Country.

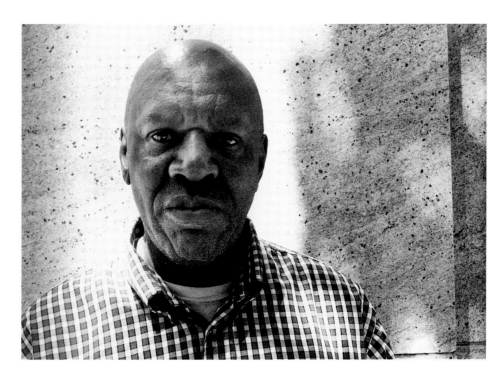

Earl Smith, Retired from the Armed Forces

My one wish for Black Americans would be that they take advantage of every opportunity available to provide them with the finest broad-based education possible. Knowledge is extremely empowering for everyone, regardless of skin color.

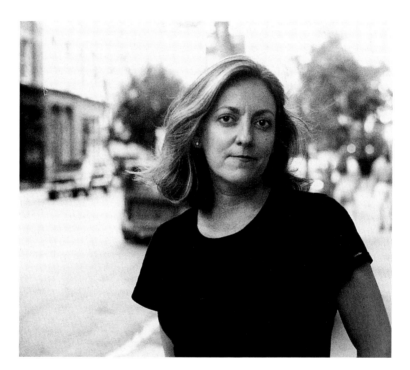

Mara Papasoff, Real Estate Agent

Listen without prejudice/Observe without comment. When observing a social, cultural or ethic phenomenon that is new to you, it is particularly important to enter with an open mind and heart and resist the temptation to get involved. Your participation might be welcomed, but can also change the character of the activity inasmuch as participants might be self-conscious or focused on educating you. If you feel the need to recount such events, do so with tact. I find it insulting to listen to people speak in "definite" terms about matters which they have only cursory knowledge of. It is critical, particularly when writing, to check the facts and appreciate that there may be more to what you experienced than what showed on the surface. Often, things left unsaid or undone are more important than what was said or done. Moreover, many things are symbolic or replete with hidden meanings. One cannot take a "snapshot" and turn it into a feature film without a considerable investment. Lastly, don't think that you know my struggles because you walked a mile in my shoes. I've walked hundreds, nay thousands of miles and still don't know everything about them.

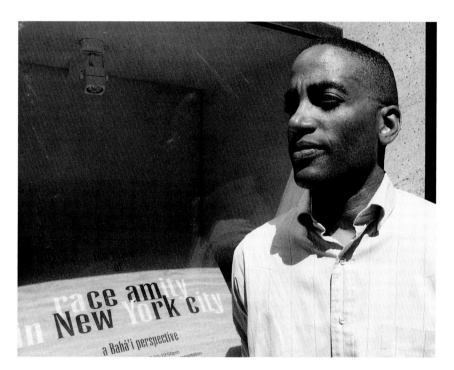

Gilbert Smith, Engineer

When does the change of heart come? And I ask the same of White Americans: When does the change of heart come?

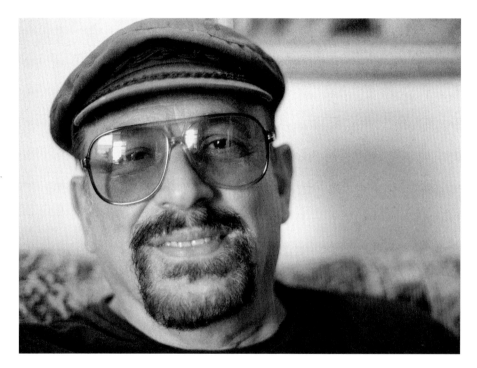

Mike Longo, Jazz Pianist

Your question makes my heart jump inside my chest and call out FRIENDSHIP. Please when you see me don't assume that I am a racist, but look into my eyes and see that I am looking at the beauty of your soul. We are one family.

I see color, and I rejoice in all the colors. I love the diversity of how we the peoples of the earth go about our daily lives. Take me into your life and I'll take you into mine.

And then the mind wanted to speak. We must be careful how we raise our children, especially our sons and through our love and guidance empower them to be fathers and leaders in this transitional world, and give our Black sons the courage to break the barriers of oppression and to teach our White sons the virtue of sharing to move over and admit to leadership and authority. The sons of Africa and Asia. And some how the illusion of racism is linked to the illusion of masculine superiority. So we must also, simultaneously, break the mold of sexism. The Forces of Light operating from the realm of the Unseen are pulling us together as one family of this beautiful Earth.

And what I wish for all of you is therefore exactly what I wish for all of us. Ultimately there is no all of you or all of us. There is really only US.

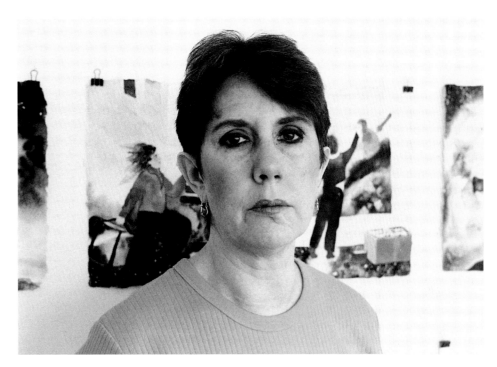

Jalaliyyih Quinn, Painter/Poet

I wish that White Americans would give up their false sense of superiority. That White people would stop thinking that African Americans are too sensitive every time we feel "Race" might have something to do with a negative encounter we have with White people. It's the on going subtext.

<div align="right">Nancy Ewing</div>

I wish that White America would simply admit that they're part of the problem and that they would beg to be part of the solution.

<div align="right">Geoffrey Ewing</div>

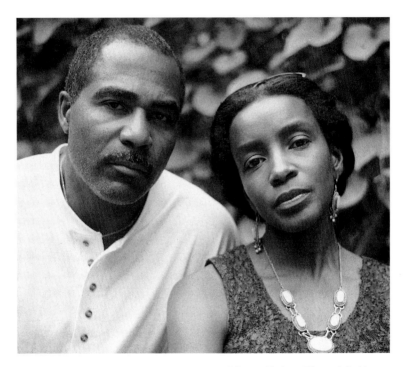

Nancy Ewing, Playwright/Actor
Geoffrey Ewing, Playwright/Actor

I would like them or to see them express, in a constructive way, where we need to go and where things could be synergistic rather than coming up with an opinion that could be different and can get us nowhere. Their point of view about where we're heading is out there and we could take that point of view and work with it so that we can have more understanding.

We have to listen to each other a lot more and listen to each other in an engaging way that would be constructive. I would like Black Americans to come to the table and express their point of view without anticipating what the other people will say to respond.

I would like Black Americans to be open minded.

I would like Black American to take some of the things that have been done well and build on them.

I would like them to express themselves openly and really work together with their fellow Americans.

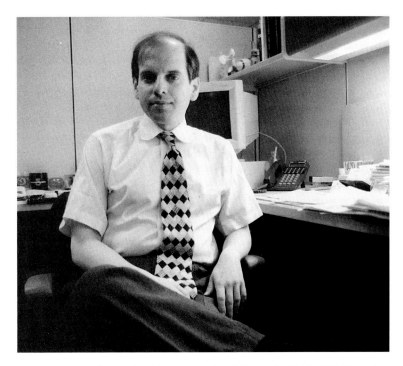

Simon Applebaum, Senior Editor of a Cable TV Magazine

To have economic parity with my White counterparts.

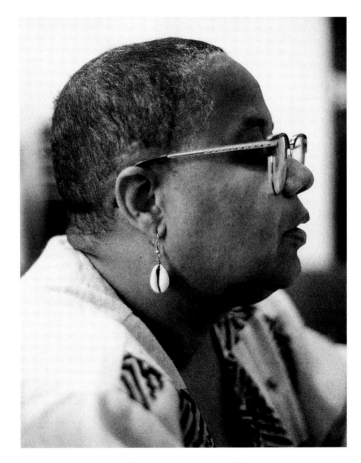

Pat Simon, Director of a Community Development Organization

I would want them to stand up proudly and know their worth to know that they offer a contribution to people like anybody else. Pay much more attention to education so that they can move forward in the world and not be stopped by a lack of education.

Recognize the good that is in all human beings. I think that a lot of Black people walk around with a chip on their shoulders and they bring that into every interaction in their life instead of looking for the good they look for the bad.

Meryle Sher, Opera Singer

I wish more White people would learn to be social explorers. That is, I wish that they would more often loosen themselves from the comfort of what is familiar and endeavor to engage that which may at first seem foreign or cause anxiety. At bottom, this is my wish for everyone. That we come to know the dual potential of things and then intrepidly strive for the greater and usually more difficult of the two. That after acknowledging the dangers of leaving behind that which is understood and safe, we courageously explore things that are different and sustain our own vulnerability at the prospect of individual growth and discovery. Again, I wish more White people were explorers, social Marco Polos so to speak.

Scott Eastman, Social Philosopher

I believe the root of all prejudice is blind imitation of the past and a severe lack of individuals investigating the truth for themselves. When we stay isolated in our own worlds without caring to learn more of another way of life or even worse believe preconceived assumptions about other people, we generate and perpetuate ignorance. Ignorance is the beginning of prejudice.

Therefore, I would wish for White Americans to let down any defenses they have about feeling guilty or blamed and from an open mind really get to know and understand other cultures and races ways of life from a humble heart, not a patronizing one.

Kamal Sinclair, College Student/Professional Dancer/Performer

I wish that we could know what it is like to be in their world and that they could know what it is like to be in our world.

Walter Masterson, Professional Consultant on Wall Street

My wish is for White, Black, Red, Brown, and Yellow to find common ground on the ONE.

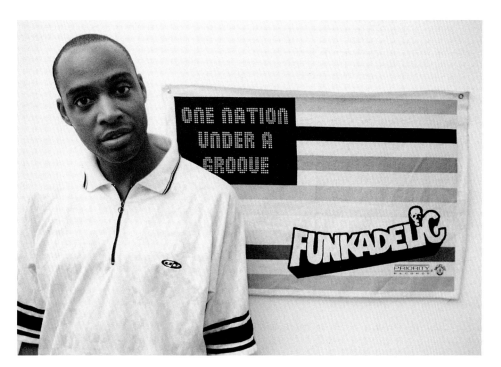

Darryl McCane, Filmmaker/Actor

My wish is taken from the words of a simple prayer: "That we all be one in mind and spirit, Putting all prejudice aside". - Barbara Osborne

I would like Whites to live through "The Day of Absence"; live Black for one day. - Ernie Osborne

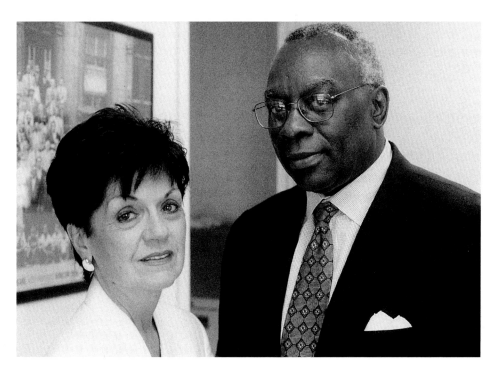

Barbara Osborne, Production Supervisor
Ernie Osborne, Executive of a Non-Profit Organization

When White folks do or say something irritating, I wish African Americans could see their awkwardness, naïveté and apparent insensitivity as an educational problem, not a moral problem.

I think it's hard to understand just how much most White people don't know. At 28, when I had my first substantive conversation with a person of color, I thought of myself as well educated and pretty much free of prejudice. However, because I had lived my entire life in all-White neighborhoods, gone to all-White schools, and attended all-White churches, I had frankly never given Black people more than a passing thought. I had no clue what it meant to be Black in the US (or anywhere else, for that matter). I had never read a book by a Black author, never picked up a magazine aimed at a Black audience, never actually thought about race as anything that concerned me.

I don't think any of us knew, at that time, how deep the problem of racism was or how intractable it would prove to be. Almost 30 years later, disillusionment has set in. Integration is a dirty word. Both Blacks and Whites have become prickly, defensive, and tired. Not surprisingly, we find it easier to stay out of each other's way.

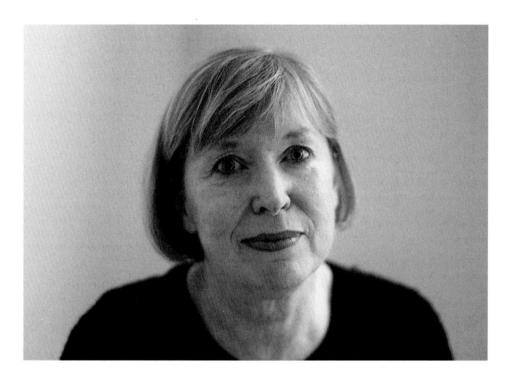

Jan Smith, Editor

I wish that Whites would stop thinking that they are superior and stop being smug about their attitudes. Their solutions are not the only way to resolve situations. The question is truly difficult to answer because not all Whites are the same in this respect. It's very difficult to put things in a black and or white generalization because everyone is an individual.

I have compassion for them because I don't think they know that they are perceived that way. In the end my heart goes out to them because they don't know any better - this is what they were taught.

I would like them to see that behaving in a superior fashion is ultimately self-destructive. In a bigger picture - any faction of society, White or Black, rich or poor or the like who think and behave as superior would be detrimental for the well being of society as a whole.

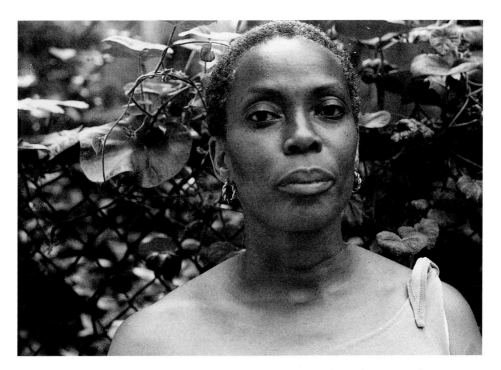

Marilyn Johnson, Mother

What hits me most immediately is for the Black Americans to let go of the past and embrace their inherent ability and to recognize that we are all truly one. That Black and White and every hue in between shares a common humanity. We can and we have the capacity to communicate and to empathize with each other and with the proper education and training, we have the ability to listen to one another.

There is a real sense of concern on why the entitlement — why is there this constant sense of grievance. When will Justice be achieved? When is enough, enough? For how long will the argument that they were slaves last? "Victimism" can last forever if we let it.

If anything, I have to remind myself constantly that there is this issue of racism. It is so easy to forget that there is a problem when you are White middle-class.

Jeff Huffines, NGO Representative of the UN

My wish to begin with on this journey in life we share is that you and I could see each other through a lens of gentle acceptance for each other's authentic and loving nature; the wish that you and I could engender trust and respect for each other in both our differences and similarities; and finally, the wish that you and I could together build a new bridge of understanding between and among all peoples, knowing that in our hearts, we are each a reflection of Divine Spirit, Namaste' my friend.

Christine Korb, Music Therapist

To be aware that racism is not just something that one person does to another. That "racism" is just another word for evil. We all are injured by it no matter what race we are. Therefore, I would ask that White people not see racism as another thing to free others from, but to realize that we are all oppressed by it and must all seek to be free.

Parisa Fitz-Henley, Model

I wish for Blacks; the capacity for forgiveness, the desire for unity and unquenchable hope and optimism that the reality of Oneness will replace the false, man made divisions that exist in present society. I wish for Whites; to recognize the organic unity of humanity and to feel pain and loss, not guilt, personally when they encounter inequity or injustice.

Eric Foxhall, Network Technician

Tremendous Forgiveness

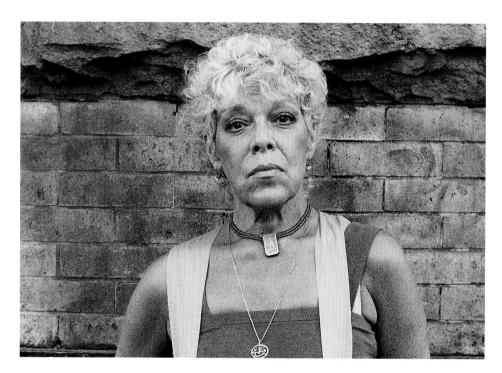

Dora Carlyn, Makeup Artist

I wish that people would stop complaining about reverse racism. There are members of the White community that are claiming that Affirmative Action produces an unfair advantage for people of color. This is ridiculous! I have never heard anyone White complaining about White privilege or the benefit of being a legacy. Since the inception of this Country, Black people have never been welcomed into the job market, regardless of how qualified they were or are, except for slavery. The truth is that no matter how qualified a person of color is, he or she rarely receives financial compensation that is comparable to that of a White male with equivalent qualifications. Racial biases are as old as the United States, yet, no one wants to acknowledge it. However, when qualified people of color get well-deserved opportunities, in a society that has historically impeded their intellectual and professional development, then an unfair advantage is being given. This type of thinking is as illogical as judging a person's intellectual capacity simply by looking at his or her complexion. A phenotype is just a natural reaction to an environment, yet in America, it can be a barrier to success. We have not made our color an issue—some White people have. I just want the glass ceiling to be removed so that everyone has not only equal opportunities but also equal access to enjoy life in this Country of ours.

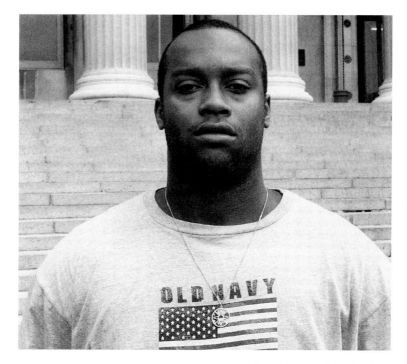

Guy Maurice, Law Student

I would ask them to heal themselves because they are not alone.

Well, if we don't heal ourselves it remains like a cancer inside of us and we become hurtful to ourselves and our families and to everyone around us.

We are all the same if we look inside of each other!

We are all the same if we could just get past the exterior!

We are all the same!

Well, I would just be happy to the fact that they would truly love themselves and be able to love other people.

I love the world and would just be ecstatic if we could love each other.

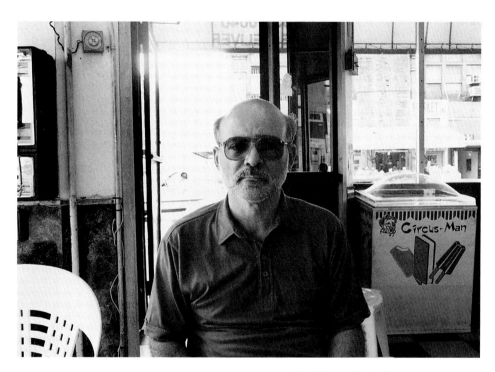

John Mateo, Parks Supervisor

In regards to race relations in America, if I could ask one thing of white people I would ask something of a particular group of white people. I would ask that those white people who are actually conscious of the severe deep-rooted racial problems in our country and those white people who are actually in a position where they can do something to impact change; I ask that they not channel all of their energy toward "saving" the poor black souls in the ghettos, but that they use most of their energy toward "saving" their fellow white counterparts who are living in their own deep dark ghetto, the ghetto of the unconscious mind. I ask that they please utilize their power, resources, and compassion to alter the hearts and minds of their "own" brothers and sisters. Hopefully, in this manner we can work from the top down as well as the bottom up. Let's meet halfway to initiate a human revolution of respect, understanding, and compassion!

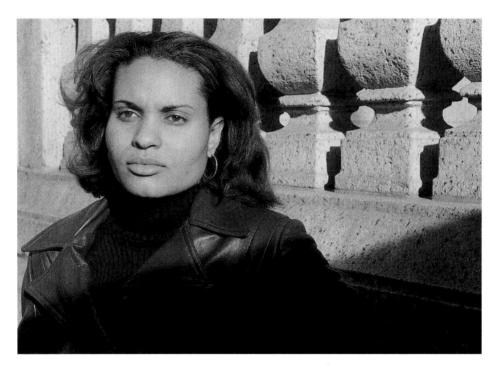

Kerri Yoder, Public Advocate

Stop the generalizations about colored people. It's like you always have to disprove the assumptions and it's always a surprise when they really get to know you.

Alex Gumbs, Student

I'd like Black men to be wonderful fathers, head of their households. Black men need to worship their women, their ebony goddess. All the "sisters" - mothers, grandmothers, girlfriends, lovers, and real biological sisters. Never have I seen such a strong bond of unity among a gender!

Women of color are the best mothers I have encountered during my 12 years as an educator. I have seen first hand broken homes and as a result broken children. A child in despair is the saddest sight a teacher can imagine. Don't let the innocent victims suffer. Please don't lie down and create a child unless you are ready to be a responsible man - a good father. Be the father you didn't have. Be the best father and husband you can be.

Care for children, God's gift, properly. Do the things your father did right. Whatever you feel in your heart that your father did wrong, learn from that and change it within yourself. Take parenting courses if you don't have a clue or take birth control to prevent unwanted babies. Love these beautiful gifts from God. Cherish all children and enjoy their goodness.

Rosie, Child Educator

Be proud of yourself.

Joe Schramm, President of Schramm telemedia

I guess I would want Whites to put aside all of the biases. I can't say where it all started, but from a professional standpoint, I feel that it is mandatory that they just drop the baggage. Because with all those biases, that is how they are looking at you as a professional. They are not looking at this person from their capabilities, but they are looking at you as "uh oh they are a Black person." So, you have a little asterisk next to you name.

I just think that we started on the wrong foot. There is something that you just cannot erase, like the how we were introduced to this Country for one thing. The whole slavery system. It is such an embedded thing. One thing that could make my wish is if we felt we were on equal footing in this Country. Reparations perhaps. It is almost 200 years later after all that has happened, we almost feel as though we are second class. I would like White America to take the responsibility for the damage that has been done.

There is this system that just won't let us in. You can have the money - you can have the education, but it is as though we are trying to knock down a concrete wall. The wall is invisible, but we all know it is there.

There is no secret that there are brilliant Black people. Time and time again, we have proven that we are just as good, if not better, at a lot of things than White people.

Sabrina Smith, Computer Programmer

If I had a wish, it would not be imposed upon so-called "Black America," a derogatory term which fails to summarize, in any fashion, the diverse cultural heritage it seeks to define and regulate. It would be a wish for people of the Americas, especially North America, and the world.

The wish would be a final wish, a wish that we would never have to wish again about race relations.

David Little, Art Historian

Books Available From Robert D. Reed Publishers

Please include payment with orders. Send indicated book/s to:

Name:_____

Address:_____

City:_____ State:_____ Zip:_____

Phone:(_____)_____ Fax:_____ E-mail:_____

Titles and Authors	Unit Price	Qty.	Sub-total
Wishes in Black & White by Eileen Williams Sabry	$11.95	____	_____
A Kid's Herb Book For Children Of All Ages by Lesley Tierra, Acupuncturist and Herbalist	19.95	____	_____
Saving The Soul of Medicine by M. A. Mahony, M.D.	21.95	____	_____
House Calls: How we can all heal the world one visit at a time by Patch Adams, M.D.	11.95	____	_____
500 Tips For Coping With Chronic Illness by Pamela D. Jacobs, M.A.	11.95	____	_____
Coping With Your Child's Chronic Illness by Alesia T. Barrett Singer, Ph.D.	9.95	____	_____
The Elephant's Rope & The Untethered Spirit: A Remarkable True Story of Healing & Hope by Lynne Picard	19.95	____	_____
Special Foods For Special Kids: Practical Solutions & Great Recipes For Children With Food Allergies by Todd Adelman & Jodi Behrend	16.95	____	_____
Gotta Minute? Ultimate Guide of One-Minute Workouts for Anyone, Anywhere, Anytime! by B. Nygard, M.Ed. & B. Hopper, M.Ed.	9.95	____	_____

Enclose a copy of this order form and payment for books. Send to address below.
Shipping & handling: $2.50 for first book and $1.00 for each additional book.
California residents please add 8.5% sales tax. Discounts for large orders.

Please make checks payable to the publisher: Robert D. Reed. Total enclosed: $_____.

Send book orders to the publisher and contact for more information:
Robert D. Reed Publishers, 750 La Playa St., Suite 647 • San Francisco, CA 94121
650-994-6570 • Fax: -6579 • Email: 4bobreed@msn.com • www.rdrpublishers.com